Exmoor Tales
Winter

Exmoor Tales Winter

A Personal Journal of Life on Exmoor

Ellie Keepers

Edited by Sarah Dawes

Layout and cover design by Oliver Tooley

Interior font - Garamond 14pt

Title font Black Chancery and Baskerville Old Face

Published by Blue Poppy Publishing, Devon

ISBN: 978-1-83778-002-0

For Ollie, Lexie and Zack
The brightest stars in the night sky.

Contents

Nana's Star

Do you ever take a moment in your life to look up at the night sky? Exmoor dark skies are amazing to gaze at and we do so on a regular basis. To be honest, most of the time we don't have a clue what we're gazing at, but phone apps help to pinpoint the planets and constellations, thankfully. Where we live, it's inky black at night. We like it like that; you find yourself more sensitive and in tune with what's going on around you.

On a clear, still night we'll take a camping chair each and plonk ourselves down under cover of our log store. With a small tot of whisky in hand, eyes directed towards the immense space above us, we watch the stunning night sky. The more we watch, the more we see; the night sky opens up its heart and shows us just what it's made of.

Stars in blues, reds, oranges, and greens twinkle brightly, with more appearing with each passing minute. There are planets to be seen and identified – Venus, Mars, Jupiter – up there in the darkness.

It's amazing … and we're lucky, as we get to share it
with each other, my husband and I.

In the darkness of the Exmoor night, we can see very little of the terrain around us. However, we know the beauty that is cloaked by the dark night, the landscape that is waiting for the sun to appear and lift its head for another

day. We don't need to see the beauty or the drama: we can feel it – and we never take it for granted as we love where we live.

~

Loving our life on Exmoor as we do, it suddenly hit me one day: how was I going to pass on to my grandchildren the love for the moor, the stories of our life, our experiences and adventures in this stunning place? Neither of us had anything from our parents to let us know of their lives, either before or after we were born. Sure, we had verbal references and memories but, sadly, they were few and far between.

We didn't want our grandchildren to live their lives wondering what our lives were like on the moor. So, we decided to make a written and photographic diary between us and the Exmoor Rambling diary/blog was

born, ready and waiting for when our grandchildren wanted to read it, for when others wished to peruse it.[1]

It concerned me, especially, that one day I would no longer be here. With my ashes scattered to the wind, who would look out for my children and grandchildren? How would they know that I'm with them, that I've not left them? How would they know that they are my shining stars and that they'll forever burn brightly in my heart?

My own parents are always with me, I know that they are there; I feel them every single day as I sit before the woodburner. We have a very close bond with our grandchildren, but the question was always hovering: 'what if they don't sense my presence in that way?' It worried me beyond belief.

On a walk across the moor there is time to think, to put your house in order and to talk to those nearest to you. Your mind is free and open and you have peace to contemplate. It was on several of these walks that I chatted to my husband about my feelings. I felt all the better for it.

A month or two after these walking chats, we took to the car around eleven o'clock one night and drove through the moor to the road above Molland. With hot chocolate in our travel cups and fleecy hats pulled down over our ears, my husband slid back the sun roof and we

[1] Never did I dream, at the beginning, that the blog would one day be turned into a series of books, one of which you are reading now.

stood on the seats, bodies squeezed out of the gap, hot chocolate in hand.

The darkness of the moor enveloped us as we stood gazing at the night sky. The view before us did not disappoint and it was amazing: the brightest stars, clusters of stars, constellations, the planets. There was no moon that night, with her being in her dark phase, but that made it all the better.

A shooting star shot across the blackness and I reached out for my husband's arm as the star disappeared from sight.

It was then I realised that he had his phone held up towards the sky and was concentrating on the stars app on the screen. He directed my gaze towards the left of us, pointing out a star in the constellation of Auriga, which that evening was to the left of Orion. He explained that the brightest star in the centre of the constellation was mine, that he'd bought it for me and that it was registered as 'Nana's Star'. The subtitle to the name was 'You Will Always Shine Bright'.

'Don't ever worry that you will not be nearby or will not have a connection, because you,' he said, 'will always shine bright – in their lives and over Exmoor.'

~

Now, there are those of you that may think I'm a sentimental old fool, soft around the edges, and that my husband follows suit. True in some respects. But, bless that man, that's all it took. Now I am at peace. I know

that our grandchildren will have a record of our lives, through words and photographs that come from our hearts, and that I will always be here, in the shape of a star: Nana's Star. It will shine the brightest of all, so that my beautiful grandchildren will always know that I am with them, watching them, urging them forward and sprinkling them with stardust, always.

Our Flexible Friends

Let it never be said that Exmoor is dull. Whether we're indoors or out, life can be challenging here, and being flexible and patient is a virtue. Here on the moor we have to look after each other and help where we can – we never know when we're going to need a helping hand or, indeed, what skill sets we're going to require. However, I always find that it's healthy to have a good attitude and a smile ready when the going gets tough. Sometimes I think they're the only skill sets I possess, but they've worked for me so far.

~

The call had come out that my happy disposition was required next-door, in the fields. It seemed that some heavy metal gates and pens had to be moved. The John Deere tractor was out already, chugging away, and the wind was blowing a hooley, making it quite chilly in the top field. Well, I couldn't stop laughing at the antics that followed and was quite sure I was being more of a hindrance than a help.

While the tractor lifted the wide, barred gates, we had to steady them and walk with the tractor to their destination. The wind was fierce! We couldn't stand up to begin with, and were clinging onto the gate with every bit of strength we could muster, shouting our words into the wind for only the trees to hear.

Following that, we were trying to balance ourselves at a 45-degree angle, while contending with the contraptions we were moving, which was great fun. It was a sight for sore eyes and if anybody had clocked us in our task then I think we'd have made their day. The tractor driver was amazing – it was us on the ground that was the problem.

Job done though, and we were absolutely exhausted, having fought with the wind and prevailing rain. With ruddy cheeks we traipsed off to the homestead for a well-earned cuppa.

I was once told that if the wind, rain, hail, or snow could be seen blowing from right to left across the cottage's front window, then, with a few deep breaths, all would settle down soon. However, if it came blowing in the opposite direction, then we were headed for trouble: heavy snow, floods, or severe wind damage. It was a weather forecast that served us well.

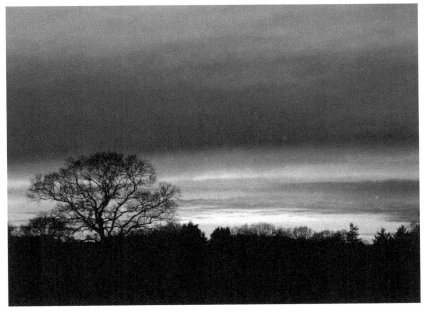

On that day the wind was blowing from the right direction but it was still extremely strong. My neighbour had further chores to do and I was off to take advantage of collecting some starters and lighters for the woodburner. Every cloud has a silver lining and the wind had certainly brought us that: twigs and branches aplenty to be picked up and barrowed back to the log store whilst the pickings were good.

It's always a welcome outing, the day after a huge wind, to go out picking up sticks amongst the fallen leaves. Something for nothing – you can't go wrong, and it makes the warmth you feel from them all the more comforting.

Anyway, good neighbour that I was, I had suggested that I cook for my two friends that evening. With the responsibility of caring for their animals, it was on very rare occasions that they were able to venture out. Their work was never finished and I thought they'd enjoy a change of scenery and being able to sit down to a hot meal with us. To be honest we took it in turns to share a meal whenever we could, so this wasn't something out of the ordinary.

I'm mostly one of those hearty cooks – a true meat and two veg or 'chuck it all in one pot' cook. Woodburner casserole is my absolute favourite and I often have a pot of something simmering on the woodburner all day. The smell plays with your head, making your mouth water. It drives visitors to despair; coupled with the smell of wood

smoke, it makes a heady combination. There is nothing like coming home to the smell of a good meal ready and waiting to be served, meat falling off the bone, vegetables, and juice waiting to be mopped up with crusty, wholemeal bread …

But on that day, with little time to prepare, I decided on a shepherd's pie with veg picked from the garden and maybe a rhubarb and ginger crumble thrown together – and that's exactly what I did. Listening to the growing wind outside, which was hurtling noisily through the tall beeches at the side of the cottage, I crossed my fingers that the power would stay on and running.

It's one of those little foibles, living on Exmoor, that you never know when the power is going down, leaving you with the woodburner, candles, and not a lot else. Don't for one minute think that I'm complaining though, for when this does occur, there is nothing that can match the atmosphere in the cottage. I feel cosseted and wrapped in love and warmth as I sit listening to music on my iPad, with no TV or other technical gadgets to confuse

the brain. I become quite inventive with meals too, with only the woodburner to cook on, but having toasted marshmallows for pudding is always a favourite. Although they are more melted than toasted with the heat that the burner throws out!

So, there I was, all set and hoping against hope that my husband made it home in time for us all to sit down together; the wind was still raging and the lanes could be quite a challenge with debris falling from the trees. I like to do things properly with a well-set table, homely and welcoming, with candles lighting the cottage. It's just what I do.

In my small but very functional kitchen, the shepherd's pie was halfway cooked, the crumble was on the top shelf doing its thing and the veg was in the steamer, which was coming to the boil. Then ... the lights flickered ... the power went off and I held my breath. It came back on again and I felt a sigh of relief leaving my body as I really wanted to cook a meal for my neighbours that evening. In my heart of hearts, though, I think it was a tall order, knowing what I know about Exmoor and the winds.

I stood in the kitchen and waited. It wasn't long before the lights flickered once more and the power was gone – this time it was for good.

I couldn't call my neighbours because the phone line had gone down too and there was no signal on my mobile. All I knew was I had to rescue the dinner somehow.

Quickly, I leapt about the cottage (well as much as I could leap in the dark – thank goodness for the candles), collecting together some large tote bags and cardboard pieces that I could line the bottom of the bags with.

Out of the oven came the pie and the crumble and into the bag they went, covered with tea towels and closely followed by the steamer containing the veg. I threw in the custard and the gravy (already prepared from chicken stock) and turned on our large lantern torch.

I had no idea how I was going to get this meal to my neighbours, but I knew if I could get it round to their kitchen and into their fired-up Rayburn, then all would be saved. As I blew out the candles, it looked like a scene from Miss Havisham's house in *Great Expectations* – although with fewer cobwebs. Just then I heard a loud banging on the back door.

The door flung open and a welcome, "Coo-eee!" came through the darkness, a chilly draught filling the cottage. My lovely neighbour had turned up with his wheelbarrow because, as he said, "There's no way I'm missing out on your dinner." Leaving a quickly scrawled note as to my whereabouts, we were off, balancing the bags on the barrow, with some hanging from the handles. We headed off together amidst falling twigs, careering leaves, and beech nuts. I sent up a silent prayer that my other half was safe on the road.

Out through the gate we tried to converse but our voices were taken away on the wind. Our heads twisted and turned in our hats, which were blowing up like balloons around our heads from the onslaught of wind. Struggling to see where we were going, with just a head torch and a small wind-up version (having left the lantern

at the cottage for my other half), we wended our way up the lane in what was practically pitch-black darkness. The wind was roaring through the trees, the creaking was quite frightening and my neighbour was protecting 'his dinner' like he was wheeling the crown jewels up the lane. It made me smile so much. After much laughter, we made it to their wooden, five-bar gate; waiting to welcome us into a candlelit and very warm kitchen was his wife.

We carried the bags from the barrow and placed the pots and pans onto the heat of the Rayburn to continue their cooking in peace. The arrival of my other half completed the foursome; he swung the lantern in the darkness of the night, to let us know he had arrived at the door safe and sound.

Together, we cooked and dished up our much-travelled dinner, while drinking mulled wine left over from the Christmas celebrations. Together we sat, as friends and neighbours, together we shared our meal and we laughed, and together we said our thanks for flexible friends.

It was a comforting meal, if not quite as I'd planned it to be. We can never know what's around the corner, living in a place such as this, but being flexible and ready for the simple pleasures in life works every time. Memories were made that night, that's for sure.

PS: Power was restored at three o'clock that morning and a tree came down in the front garden, giving us yet more wood for the woodburner. Every cloud, as the saying goes ...

A Five-Minute Job and Kestrels

Following a fitful night's sleep, where the wind had been howling around the cottage chimney, the tall beech trees had been roaring, wielding their branches in tangles and twists, and the rain had lashed at the windows, we woke to a surprisingly bright and clear day. The early winter sunshine poured from a cloud-free sky. Going to the landing window for a peek across the moor, I could see debris in the shape of twigs and small branches littering the paddock. Good pickings for starters and lighters to be picked up later that day; nature always a giver.

Mugs of tea were required so I made my way down the curved stairs and popped the kettle on before padding along to the front room to set the woodburner in motion. As the wood caught, I returned to the kitchen and began preparing some wholemeal granary toast and marmalade to go with our tea. I shouted up the stairs to my husband that breakfast was ready, and he joined me in front of the fire to discuss our plans for the day. We both find it homely and comforting to sit with a simple breakfast on the sofa

sometimes, with our legs tucked under us, the warmth of the fire surrounding us. It was decided that we'd pop along to Wilmersham Common, up above Exford, for a couple of hours in search of kestrels.

We'd had some fruitful times up that way in the past observing the beautiful birds as they hovered, dipped and dived above the combes, and hadn't been for a few weeks. So, Wilmersham it was.

However, there was a pressing job to be completed in the garden before we were free to leave. We have two pieces of trellis that act as a peaceful seating area and which will be covered in sweet-smelling honeysuckle, clematis, and two fragrant roses, come summer. One of the posts supporting the ageing but 'holding-out' trellis had fallen foul to the high winds that gust across the moor.

To set eyes on the construction posed a conundrum; was it the trellis holding up the climbers or the climbers holding up the trellis? Either way, the post had to be dealt with, needing to be replaced before the new growth started. We decided to tackle it; a simple task, a five-minute job, and we'd be off and out across the moor in no time.

We soon found out that this was not so, as we fought to relieve the wet and sticky ground of the ball of concrete holding the weak post in place. Wellington boots grew heavier as an inch of muddy soil clung to the treads. Hands, despite the protection of gloves, became sore and weakened and bodies ached with the tugging, digging and wriggling of said post.

We'd walked that much soil across the grass, in two hours, that we could have formed another flower bed with it! Whoever had put the post in originally certainly didn't intend on replacing it any time soon, that was for sure. A tea break and a re-group was called for, and we sat on the old wooden bench up from the front gate, our hands wrapped around our mugs of 'thinking liquid'.

A brave and beautiful mistle thrush flew onto our old, gnarled holly tree, with a clap of its wings and a chattering call. While we watched – as he gorged on the red and ripened berries, way up high, vigorously defending the tree from our resident blackbird – it was decided that we'd clear away our debris, wash the mud from our boots and go for our walk up on Wilmersham Common. We'd turn it into a 'ponder-wander' about our predicament, as we searched for kestrels. It was a unanimous decision, so we left the mistle thrush to its lunch and cleared away.

Back in the warmth of the kitchen, while packing ourselves up some sustenance and a flask of coffee, we wondered why it was that the simplest of tasks usually turned into your worst nightmare. It was an ideal day to work in the garden, but why fight with something when there's Exmoor out there, waiting to give you something more than blistered hands, aching muscles, and wellie boots with a three-inch sole to them?!

It being early winter, we dressed for warmth against the cold. Bright it may have been, but we knew there'd be a chill waiting to wrap itself around us once out on the open

moorland. It would creep and seep into our bones if we didn't cover ourselves. I always reach for my green Bear Grylls fleecy inner layer, which I found in a charity shop many years ago. It is the ultimate layer to have on in such weather, was an absolute bargain at under £5, and it never lets me down.

With waterproof coats in our trusty 4x4, we motored along the lanes, taking our time as we usually do, stopping and starting and sometimes wondering if we'd ever reach our destination. On such a glorious bright and crisp day, after the winds and wet days of late, the wheat-coloured moorland looked fresh, clean, and vibrant. Cattle, with winter coats of velvety-black looking relatively clean considering the past weather, stood aside and trundled up the grassy, heather-clad banks as we carried on by. Sheep, however, were a different kettle of fish all together.

Looking positively yellowy-grey in colour, they meandered along the side of the road, in no hurry to give up their space until we were virtually upon them. Both are part of the expanse of moorland that we love and, along with the ponies, they are an integral part of the wildness of the moor.

At Wilmersham, and in the surrounding area, there is still a feeling of openness. The moorland here is undulating, with wooded combes, hillsides, and views that take your eye towards the coast, towards Dunkery Beacon, and back to Exford. With flat, grey boulders aside the lanes, it's an ideal place to sit and watch for kestrels as they hunt above the dips in the landscape.

As we went to take the right fork at a junction, a very pretty female flew low above the tarmac in front of the

car. She came out of nowhere from above the flattened, dry-looking grass and began her flight, stopping now and then at the side of the road. As she stopped, we stopped, some distance from her. It was if she was looking back and checking we were with her before she set off again on her mission.

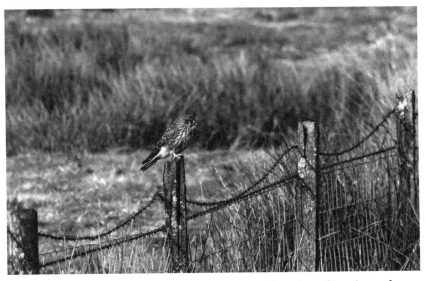

After a minute or two, she was off again, dipping along in the weak winter sunshine. This pattern continued until we were nearly at the parking spot for the Dunkery walk; we'd been observing for quite some time now.

We'd pulled up off the road while we watched for her next move, and a car came up from behind us, passed us at speed, and she was gone. She took off over the moor, up and away, hovering for a few seconds and was then out of sight. We were thankful for the time we'd had observing the kestrel in all her reddish-brown finery and

will always wonder why she was following the road with such military precision on that winter's day.

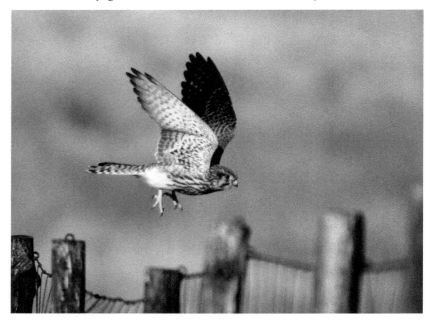

Carrying on towards the turning place, we re-traced our steps, took the lower road and parked up to eat our late lunch of quiche, fruit, and coffee. The day was passing us by and it didn't appear to be as bright as it had been earlier, but we were determined to get out and about for an hour or so and wander the moor looking for the most accommodating of birds. With a waterproof top layer over our warm clothing, we set off across the tussocky grass to a place where we've always spotted kestrels seeking a meal.

It's not easy terrain to get to grips with as the grass is spongy and springy, even when wet. The moorland

heather has knots and loops to contend with, which will grab your boot and have you over if you're not concentrating. There are also boggy bits to watch out for so, while watching up above, you also need to be watching the ground too. It's all part and parcel of being on the moor.

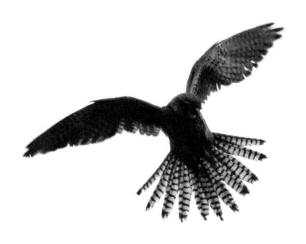

What is also part and parcel on the moor is the swift change in the weather. I see it often from the cottage windows: a glorious bright day will change in minutes as grey and black clouds roll in above the landscape, and I'm

running up the slate steps to retrieve the washing from the line before the dolloping drops begin to fall.

That day, however, we were out in the elements when the sun disappeared, the sky darkened, and rain began to fall like stair rods. Great, hulking rain drops hit us without warning and, being on open, exposed ground, we were absolutely drenched in seconds.

We were equipped with excellent outer wear, but the rain we encountered that day stung our faces and was something akin to being pelted directly with small marbles. Our wind-and-rain protective covering did the job of keeping us dry inside, but outside, as we legged it as best we could across the demanding ground, we felt pummelled. We'd been walking all of twenty minutes. Throwing our coats into the boot of the car, we fell onto the seats, along with our cameras, where we laughed at the ridiculousness of it all.

Within fifteen minutes, all was clear again; the cloudburst had passed over and was headed for Exford way. The sky was bright, but the ground was extremely wet, as were our bottom halves. I usually carry spare clothes in the car if we're out for the duration, but a quick nip out didn't seem to warrant it that day, so we had to travel home slightly more than damp.

The road was like a river as we pulled out of our parking place, the fallen rain running off the moor. It simply wasn't worth sorting ourselves out and trying again, but a hot coffee and spiced oat cookie helped to soften

the blow, and we began the journey home. It never fails to surprise us what happens on the moor when we're out and about but it's life, the weather turns and, at the end of the day, it's only a drop of water. We'd been out and seen our kestrel okay, but perhaps we should have persevered with our garden project. Sometimes it's nature's way of telling us that we should have stayed put and got on with things.

We didn't have time to ponder on our wander – there was too much else going on – but the stubborn post isn't going anywhere, anytime soon. It will still be there next weekend and maybe, by then, we'll have found our thinking caps and have come up with a solution … and, there again, maybe not.

Dulverton Deliberations

Nestling in the deep-wooded Barle valley sits the picturesque little town of Dulverton. Cosseted by tree-clad hills, it sits on the banks of the ever-changing River Barle. With its collection of stone cottages and welcoming shops, its vibrant pubs and eateries, you can't help but be charmed by the setting. The town is a pull on an autumnal morning when there are Christmas gifts to be sourced. So, on this crisp and frosty morning, with my chores completed, I find myself jumping in the car and heading down, off the chilly moor, to see what I can find.

We laugh with our neighbours on a regular basis as to how different the weather can be, just by travelling from up high on the moor to low down in the town. Up on the moor we could be surrounded by thick fog that hasn't made any attempt to lift all day. It's the sort of fog that engulfs you; that makes you feel as though you're wrapped in grey cotton wool. Yet, down in the town, you'll find it's quite tropical and exactly the opposite; a clear, crisp and bright day with the promise of a warm sun.

Today, with the weather in mind, I've chosen to wear a simple padded, green gilet with hand-warmer pockets and my trusty Dublin River boots, as an outside layer. The times I've dressed for moorland weather, with the whole gamut of winter clothing, headed into town and found it to be quite warm, have been numerous … and I never learn.

My argument is that there's no telling what's around the corner when you're traversing the moor. I like to be prepared for any eventuality. There will always be help at hand, should you run into trouble, but 'be prepared' is the order of the day for me, and always will be.

High beech hedgerows, still with their crispy, brown leaves line the lanes that I travel. They are excellent cover for the multitude of wildlife but, now and again, there will be a break in the hedge giving far-reaching views across the hills and maybe the glimpse of a red deer herd.

Sheep graze the land here, their fleeces thickening out to protect them from the winter weather to come. If I

stop awhile to look at them, they stop too, lifting their still-munching heads, to return my curiosity.

The road quickly begins to drop down, winding and twisting, with left and right turns, only to climb once more, for a short period, before falling away again. Lush, green pastureland feeds the animals along the route and the fields stretch towards Tiverton and the surrounding villages.

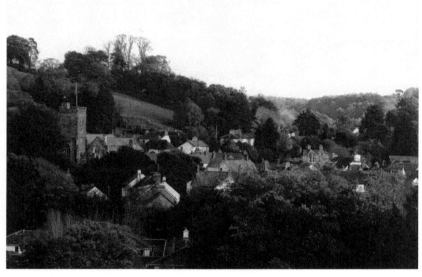

As I wend my way down towards the main B road, the woodland and its trees begin to close in. Leaves of every autumnal shade line the lanes, blown across the road, clumping up in heaps only to be on the move again, should we have a strong wind any time soon. The road

narrows here but Dulverton is in sight with its squeezing roadways, historic buildings, and the glorious Barle Bridge.

Being medieval in its origin I can only imagine who and what has passed over it in years gone by. With its five spans and the river tumbling under, it's a popular place to spend an hour or so, with a coffee, delicious fish and chips or an ice cream. The up-and-over bridge brings you into Dulverton or takes you away from it; one way probably better than the other. But I feel that's a matter of opinion, as there are lanes to drive and pathways to walk across this southern gateway to Exmoor and nothing will disappoint the intrepid traveller.

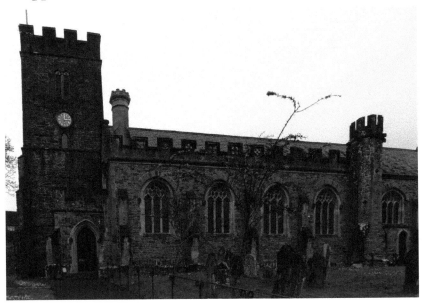

Passing the Grade II listed, 15th century Church of All Saints will always make me smile. Visiting Dulverton during the Christmas period, we will make our way to one

of the benches at the top of the slope that leads to this beautifully old church. Then in the cold evening air, we will sit together, watching almost-white smoke curling out of the undulating line of eclectic chimney pots belonging to the cottages.

There is something quite peaceful about watching wood smoke and about being able to smell the smoke from the different wood being burnt, especially in the night-time chill. It evokes scenes of comfort and warmth within the homes of many, tucked up, away from the cold of the evening – just like we will be on our return home on a winter evening. Spring, on the other hand, will give us a churchyard covered in pure snowdrops and early crocuses.

The flowered carpet of white, saffron yellow, and purple is pretty as a picture and one not to miss. No matter what season is upon us, we will always head for the church grounds and quietly watch this Exmoor town breathing, proud to be a part of it all. Today, it's busy down here, as is normal, but I'd rather see the town alive and giving, than being dead in the water. As a local, I rely on the shops here to sustain my family whatever the time of year and I'm thankful for what they supply. I'm also thankful for the community spirit here; it is top of the tree and there's always a helping hand should you need it.

As expected, the weather feels a few degrees warmer in the sheltered spot where Dulverton sits, and I'm glad I opted for just my gilet. As I wander, browsing the small, independent shops for ideas for Christmas, people take the time to chat, to say a cheery 'good morning', to offer advice on their products, to pass the time of day. It's a good feeling to know that we haven't lost the art of conversation and it all makes for a pleasurable wander.

There's a whole lot of difference to be had by simply greeting somebody with a cheery smile, and I've always found Dulverton to have that in abundance. At this time of year the shops are decorated with twinkling lights and festive window displays, in early readiness for Christmas and for the up-coming 'Dulverton by Starlight' event. The pretty windows draw you in, the setting of the town working its magic. It's a popular place and so it should be. It's delightful, and I often have to pinch myself to make

sure that I really do live in the vicinity of this sought-after Exmoor town.

Wishing I had time to stop on for lunch, I plump to go into the very welcoming Copper Kettle tea room for a quick coffee before heading home. It's a tough choice but I do try to share my time between all the eateries on offer and we frequent them all at different times. My husband proposed to me over a scrumptious meal at Woods Wine Bar and we returned there after our simple wedding ceremony, six months later, for our celebratory meal, making it a very special place for us.

Dulverton holds so many memories but, not least of all, it's where my husband's father was born, during the war years. We have his birth certificate framed on our kitchen wall as a reminder, now he's passed. Having spent long

enough wandering about, it's time to return home with my wares.

I've chutney from the deli, gifts from Browns and the Exmoor National Park shop, chocolates, and Christmas cards from The Tantivy and supplies from the Co-op. My arms are longer than when I arrived here, but I've spent an enjoyable and quite festive couple of hours pottering about.

Deciding to take the long route home, I'll be able to pick up some eggs on the way. There's a beetroot cake to be made this afternoon and I'll probably whip up some sweet potato scones too, along with a rice pudding. As my mum would say, 'you can't waste the heat of a good oven', so multiple bakes it will be. I've been spoilt by the tropical weather down in town and it's noticeably cooler as I climb the hills back onto the moor. In places the roads are muddy, with the tractors working the fields after the spell of wet weather. I'm used to it and plough on through, onwards and upwards towards home.

Telegraph poles, hunting posts for the lazy buzzards, are empty today. They stand like soldiers, in line along the hedgerow, waiting for the birds to land and wait, as they usually do, for an unsuspecting meal to come along. It's rare to see the wooden poles without a buzzard sitting atop, but today they're vacant and alone. Downwards and over a crossing that spans a trickle of water, and up again, passing gateways, lone cottages, and field upon field of pasture land.

Despite the time of year, the lush fields are painted in an array of greens. A turn to the right, with views that go on forever, affords me yet another glimpse of a herd of red deer some fields over. I stop and watch them through my binoculars. They're around thirty strong, all hinds, and they graze on 'protected' land where they cannot be hunted. They glow, russet and brown, in the weak sunshine on this crisp, autumn day. How peaceful, to be able to stop and watch the silent deer. It's idyllic and it's good to see.

On the last leg of my homeward journey, I drive through tree tunnels, now naked of leaves. Branches stretch across the lane, joining in the middle, the sky evident through the cross-cross of twiggy limbs. I stop at the next junction and take a good look across the lane.

Deer can regularly be seen at either side of the wooden gates here. Stags have been known to run in the road in front of you as you drive, no matter what time of day. It's a regular occurrence. But I don't have to peer too hard as the hedges have been cleanly cut now and visibility is slightly better, both for sighting the deer and for driving. But there's focus to be had on these lanes, as they test your concentration and driving with their sodden, grassy verges and banks thick with squelchy mud. The going is slow at times, necessarily, but the cottage will be in sight very soon. Its roof will be waving at me through the canopy of trees, the gate open and waiting to welcome me home again.

I park alongside the log store, walk to close the old wooden gate and turn in a circle; it's a habit on my return home. It enables me to take in our haphazard garden, the fields, and the view. By the back door I have a selection of herbs growing in a very large, old, galvanised bucket. I brush them with one hand as I pass, in through the back door, and step into our small, homely kitchen.

Boots off, bags emptied, oven on and the baking will begin. I've been all the way there and now I've come all the way back again. I've driven the narrowing, winding lanes, passed the ancient banks, seen the endless views. They all mean Exmoor to me. It's our home, it's our life, it's our future, and we feel blessed to be a part of it all.

A Different Christmas

Christmas will soon be upon us once again. We begin to make plans and, as we do so, cast our minds back to the previous year …

~

Last year was strange, being the first time in forty-one years that I didn't spend it with my daughter. We knew it was going to be different and made an early decision to stay apart. With the pandemic running rife where she lived, it was the best decision for us both. So, my husband and I had to make new memories that Christmas, do things in a different way. And we did just that … with the help of some strangers.

As is tradition in our household, we walked on Christmas morning, after breakfast. For once we had not been woken at the crack of dawn by our lively and energetic grandson; we were able to have our morning lemon-and-ginger tea at a leisurely pace, and at a respectable hour.

Looking out at the patchwork of fields across the narrow lane at the front of the house, we gave thanks for our health, and sent up prayers for those people that had lost family and friends. To be lucky enough to live away from the cities and big towns has never been lost on us. We know we are blessed where we live and to have the luxury of being able to stand at our bedroom window, with the moorland stretching for miles in front of us, is peace personified.

After a filling and delicious breakfast of scrambled eggs and smoked salmon on toast, with perhaps a tiny Buck's Fizz, we readied ourselves for the off.

The ham had been prepared and cooked the day before (Christmas Eve), the woodburner was stoked and keeping the cottage alive, so we donned our boots and warm

outdoor clothes, closed the door behind us and set off for our wander. As for every Christmas, our five-barred gate was adorned with greenery from the garden: holly, ivy, fir, and pine tree branches. Tied to the bunches of green were bright red, hand-tied bows, all intertwined with twinkling white lights. When we are driving home, down the lane, they shine out in the darkness to welcome us.

Clicking the latch of the gate into place, we made our way to the right, my husband checking that I had two fingers of fudge in my top pocket for our halfway treat.

Across the lane there's a gate, a wooden gate, with a perfectly working latch. No baler twine will you find on this one. It leads to a field where a flock of sheep and their bouncing lambs will reside when the spring months come.

On that day it stood empty, but it would lead us down to the cover of woodland eventually and we followed the hedge-line as we began to descend into the valley. Half

way down the lane we found another, smaller, wooden gate and crossed over into a scrubby field, where we have to dodge in and out of the purple thistles during the summer months. Making our way across the sloping field, bordered by beech hedges, we passed comment about how it was good that the hedges were laid in the late summer months. We know there's the promise of new growth in the spring, from them being tidied up.

Over another, slightly dilapidated gate, we entered the sombre light of the woodland. Despite the skeletal, naked trees allowing light to reach through the canopy of branches, it remained more subdued than the fields. A criss-cross of paths, over the dampened ground of leaves and soft pine needles, saw our feet tread silently as we dropped even further down towards the River Barle.

The sharp and carrying bark of a red deer hind rang out from between the trees. We'd been seen and reported, and stood still to see if we could spot our vigilant observers. About fifty yards ahead, deep into the woodland, a small herd of eleven hinds trotted across the muddy pathway to our left. Akin to dainty ballerinas, they made their way further into the deeper cover of trees, away from us. We watched them blend and disappear between the trunks of our native trees before we set off again, listening to the birdsong, clear as day, as we walked.

Moss-covered fallen branches crossed the tracks as we negotiated further down the sloping woodland floor, trying to find the best way to the silver ribbon of water that is the Barle. By the time we reached the tumbling river, our spectacular view across the valley had been swallowed up all together by the rich woodland. For two miles we walked alongside the meandering flow of water, keeping it company as it wound its merry way through Castle Bridge, Marsh Bridge, Dulverton, and towards the Exe.

We met two or three couples walking in the opposite direction to us and bade them 'Merry Christmas!' as we passed. It was all very jovial and so good to see other people out and about on that Christmas morning. Our heads were covered with our woollen hats, our necks wrapped up in our scarves, our hands clothed in our gloves and yet the river managed to make us feel chilly.

There was not a bird in sight along the river itself, but blue tits and great tits flitted in and out of the undergrowth and lower branches of the nearby woodland. The quietness of the morning was broken by the song of a lone, seasonal robin, its song a reminder that this was Christmas morning, and that we needed to make tracks for home, to prepare dinner.

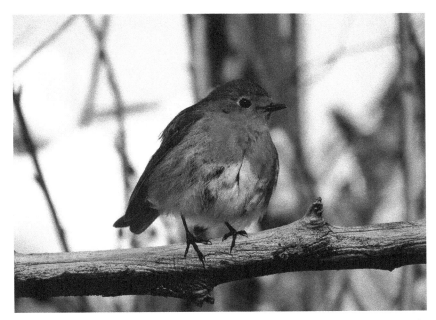

Thoughts of the fudge in my pocket spurred us on – it would be the prize for tackling the next uphill steps of our wander. Up through the mossy, damp trees we went, ducking under and climbing over fallen branches and trees. They had become another form of habitat for wildlife; their living days were over, yet they continued to provide in a different way. The tracks we then followed took us to a lane and, eventually, across fields towards home. It was a climb, up to the lane, but it brought the warmth back to our bodies as, step-by-step, we progressed up the steep slope.

Pheasants in all their colourful glory called out in the stillness of the day, shattering the peace and quiet, as we reached the relative flatness of the lane. With enough room for one vehicle, the roadway is narrow and winding,

with beeches, standing tall, at intervals alongside it. Where the woodland falls away to one side and back down to the river, we stood at a cold, metal, barred gate on the opposite side of the road and looked away and across the fields of greens and browns, while we ate and enjoyed our prize.

As we stood there, each with our own thoughts, a 4x4 came towards us. It slowed and stopped and we turned towards it, thinking we should perhaps know the occupants. Suddenly, the windows were down and three heads poked out, glorious red Santa hats perched at jaunty angles, and began to sing, in perfect unison, a rendition of 'We Wish You A Merry Christmas'!

Absolutely stuck for words, but being able to find my singing voice, I joined in and conducted, too, as we stood at the gate on that beautiful Exmoor lane. After they had sung two verses at the top of their voices, we all clapped, and the windows began to close to the shouts of, 'Merry Christmas!' With their Santa hats waving out of the closing windows, they were gone.

My husband and I looked at each other as if to say 'did we just dream that happened?' We had no idea who they were – didn't recognise any one of them – but they'd made our day. Strangers had taken the time to stop and sing to us, down a country lane on the moor – what a splendid memory to store away. We wondered if they knew what a difference they had made to us on that

strange Christmas Day. Bless them. Bless them, every one!

Then our feet pulled us on towards the warmth of home, a Christmas dinner, contact with our grandson, and

present opening. The cottage was dressed, the greenery in and present, and peace and love was with us in droves. If that was how Christmas was to be that year, we thought, then we had a lot to be thankful for. There was a warmth inside us that only happiness and contentment can bring.

There just might have been a glass of Dalmore whisky waiting with the Brussels sprouts and carrots on our return so, best foot forward, down the winding lane and across the fields we traipsed, swinging our arms happily as we walked, homeward bound.

A Winter Frost

Throwing back the covers this morning, I felt the chill in the air hit me fair and square and made the assumption that it must be earlier than I thought. Closer inspection in the inky-black bedroom told me it was just a couple of minutes after four-thirty – no wonder I'd felt the chill. The warmth from the woodburner travels up the chimney breast in our bedroom, from the lounge below, and it will remain warm for a good part of the night hours. Come the early morning though, the warmth has diminished and we'll feel a chill encompass the room.

As is usual for me, I headed for the window in the cosy back bedroom, smiling to myself as I picked my way across the landing. The smile came from knowing that, although I would not be able to see one solitary thing in the darkness outside, I would still look. It's a habit and one that I know I'll never grow out of. However, once I had peered into the velvety-black sky for a moment, the stars became visible to me; I had grown accustomed to the darkness.

The planets that could be seen in the evening hours before bed had long since dipped below the horizon, but I was sure that I'd see Venus glowing at me from between the trees, if I ventured to the small and perfectly formed bathroom window. With the stars and the chill, I was certain there would be a frost come morning.

I padded silently back to my bedroom, having checked that all was in order outside, tucked myself down in the most comfortable bed, and listened to the moor. As a tawny owl lulled me with its call, I drifted off into sleep for another couple of hours.

Sure enough, there was a thick hoar frost covering the ground when I awoke again. Like the icing on a Christmas cake, the frost glistened on the window sills outside as I began turning lights on.

Warmth from the heating was now taking the chill off the rooms but the day is never begun until the woodburner is up and running. It didn't take much persuasion to leap into life this morning, and with the orange flames licking around the logs, the cottage awoke from its slumber.

Carrying two steaming mugs of tea, I climbed the twisting staircase to wake my husband and ready myself for the day, the steam from our morning sustenance curling in the now warmed air.

~

As the first light of day takes hold, I busy myself throwing a chicken casserole together. Carrots, onions, leeks, celery, potatoes and chicken, browned with a paprika seasoning, are all sitting in my cauldron of a pot atop the woodburner. There it will very slowly simmer away for the day, the tantalising smell drifting from the cottage each time the door is opened. When I spend the day working in the garden, it's good to know that dinner is looking after itself, that we can both come in and sit down to a relatively quick meal in the warmth of the kitchen.

I work while keeping an eye on the garden, and spot an extremely colourful pheasant perched on my tall gate post, the richness of its plumage a direct contrast to the stark background of frosty, mottled white. As the thought crosses my mind that the scene before me would make a most excellent Christmas card, he takes flight, emitting a loud and angry cackle. The look of disapproval he gives

me as he takes off makes me smile. I wonder if he is one of the culprits who have been scratching up my flower beds – and I decide that he is.

I feel like I've neglected the garden, as it is looking somewhat bedraggled after the howling winds of Christmas Eve and the wet weather on the following days, not to mention having been trampled by the aforementioned band of unruly pheasants as they pecked, poked, and prodded about through my borders. I decide it is time for a spruce up. With the bird table replenished and the ice on the water butt and bird bath broken and refreshed, I am ready for some physical work.

The air is crisp and the ground sparkles; winter appears to be taking a hold on the earth. But it looks as if the frost is clearing quickly to one side of the garden, where the morning sun is laying itself down across the lawn, and

there looks to be a promise of blue sky, which is trying so hard to show itself, despite the freshness of the air. Grabbing my leaf rake, hoe, and trusty wheelbarrow, I make my way up to the top garden, with my old black gloves protecting my hands from the icy and very cold handles.

Down the lane I can hear a tractor and a quad bike out, the sheep calling a grateful 'thank you' for their early morning meal on what is probably the coldest day we've had so far this winter. It's a bit of a squeeze, manoeuvring the barrow down the narrow pathway between the fence and the hedgerow, and I decide to trot across the paddock. It's a longer route but it means I can have a quick look for evidence of the red deer as I totter over the undulating tussocks. The wheelbarrow leaves tracks as I push it over the frost-covered grass, and I can hear the velvet song of a robin calling from the cherry tree across the way. There is no doubt that he will be joining me once I start to rake the leaves and debris from the flower beds; robins are never far away when I'm in the garden.

The robin's favourite perch, while waiting to swoop in for a tasty morsel, is on the lower branches of our cherry tree. He sings to his heart's content, head cocked on one side at times, as he waits to pounce onto the ground I've cleared. As I work, raking and hoeing up the flat earth where the pheasants have been scratching about, a plethora of blue tits flits backwards and forwards to the fat balls in the bird feeders.

I have several feeders hanging from various trees around the garden and the great tits, coal tits, and blue tits are always busying themselves, their wings whirring as they feed, a constant blur of blues and yellows. Some choose to take a nut or sunflower heart from the bird table, fly to the adjacent acer tree and nibble away, while securing it with their little foot on the small branches. Wherever they choose to feed, there is never any waste as the chaffinches and dunnocks pick up what is dropped before the pheasants, pigeons, and jackdaws appear.

All the birds seem to be growing brighter in their plumage now. They're maybe not as colourful as when spring approaches but there is a distinct difference and sharpness to their feathers. A few weeks ago the chaffinches would have blended in with the branches of the trees, but now I can see their dusky-pink breast and white bars quite clearly from a distance. The coming season may seem a long way away, but already the signs are here. The days will lengthen, the evenings will lighten, and new life will begin.

I only intended to partake in some raking of leaves this morning but, as is always the way, I get carried off on the wind when I'm working out here. Soon, I find myself pulling at the now dead and rotting bracken and fern leaves and hoeing around the larger shrubs, careful not to take the tops off the bulbs that are pushing their way through the hard ground already.

Snowdrop shoots are around an inch tall now and soon their clumps will burst with delicate, pure-white flowers, their citrus-green centres hidden from the eye. For me, they herald the end of winter and the promise of the coming spring. I can only look forward to them now, as I hoe carefully around the base of the fresh new shoots.

Time passes on and I venture down the path and into the warmth of the cottage to make a well-earned coffee. The simmering casserole invades my senses as I push open the back door. As is always the way, the cottage kitchen welcomes me in and asks me to stay awhile in the warmth. But, with leaves still to be raked, I turn and take my gingerbread latte back out into the garden.

There's a warmth to the day now, probably from the physical work I've been doing, so I take a seat on my old wooden bench, just up from the front gate. Here I can sit

and watch the world go by – and probably the postman, too: it's about his time of day to call.

To the right of me is a dense beech hedgerow, atop an ancient bank, punctuated by tall beech trees. We know from old maps that this bank, and the lane the other side of it, has been here since the early 1600s. The gnarled and twisted stems of the beech hedge have probably been laid time and time again over the years, resulting in the healthy state the hedge is in today. It's a home and haven for so many animals and birds who frequent the garden, and who use it as a cut-through to the lane and to the open fields beyond. I guess the hedgerow has stories of old to tell and I wish we could talk at length sometimes.

There's only birdsong to reach my ears as I sit peacefully on the bench on this bonus of a day. Starlings high up in the beech trees draw my attention with their Morse-code-like call, tap-tapping away, and I spot a buzzard across the sky. It's alone and appears to be on a mission as I watch it fly in a straight line towards me. It makes several short, sharp flaps with its wings and then glides a short distance, then short, sharp flaps and again a glide. The pattern of flight carries it towards me, directly over my head, and away.

I don't think I've ever seen a buzzard fly in a direct line before. I've watched them dip and dive, soar and circle, perch and battle – but never fly in a straight line. As it flies directly over my head I have a fantastic view of the underside of its plumage and feel it has been well worth

taking five minutes to sit down with my coffee, on my bench.

Time to work again, though, as this will 'never get the baby fed', as my mum would say.

Frost still lies on the shady side of the garden, crisping up the stubborn ferns that remain, and clinging to the berries and rose hips. The red-and-white colouring is reminiscent of the festive period and reminds me that Christmas has only just passed.

I shouldn't be getting ahead of myself and wishing my life away, hoping for spring to arrive, but against all the odds there are delicate, yet hardy and brave, primroses already in bloom, dotted about the garden. It's very difficult not to imagine warmer days when faced with such beauty.

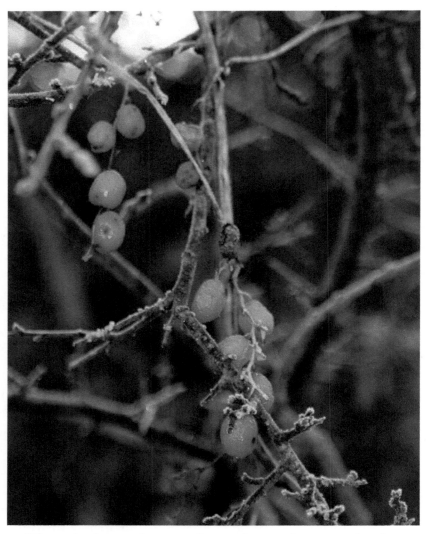

There isn't much more I can do out here, as the frosty grass prevents me from walking over it. With a last rake around, I bundle my tools back onto the wheelbarrow and retrace my steps to the shed.

Another tractor approaches along the lane, its steady drone piercing the crispness of the day and, making my way to the gate, I wave to a neighbour as he passes by with a bale of hay loaded on his John Deere. He'll be back along this way soon enough: his work is never done.

Tools packed away, I wander towards the gateway across the lane. It's sheltered here below the now skeletal beech trees, and the frost still remains. It clings to the wood of the gatepost and sits across the gate and the barbed wire to the side.

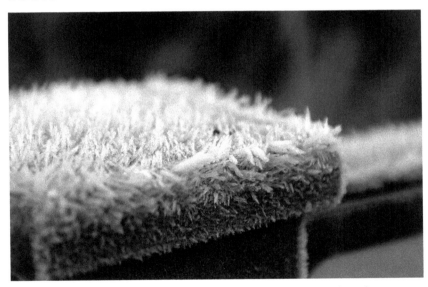

Along the wire fence the robin sits on a circular post; it's almost a cliché, but he really belongs in this day, perched on the post with its dusting of white. His song is long and loud and he is happy.

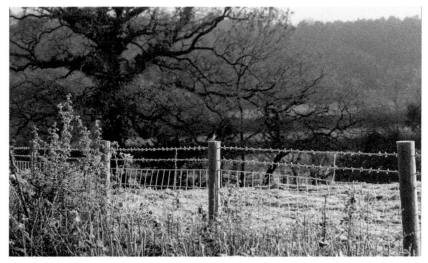

I could stand here all day, looking across the Barle valley, but there's a log delivery due this afternoon – and lunch calls. I need some sustenance inside me if I'm to be moving and stacking logs as my afternoon activity. It's always satisfying to see a well-stocked log store and it won't be a chore, but a pleasure, on this chilly but blue-skied day.

Now the garden is tidier, a hearty bowl of homemade spicy parsnip soup lures me back to the cottage. I discard my muddy boots in the boot room and, in an instant, the warmth wraps itself around me once again, the stillness and quiet crowding me, just the way I like it to. While I've been busy, the cottage has been busy too, making ready with her welcome. I feel it with every bone and every fibre of my body. To many she is just bricks and mortar sat upon a plot, nothing special to look at – but, to us, she is home.

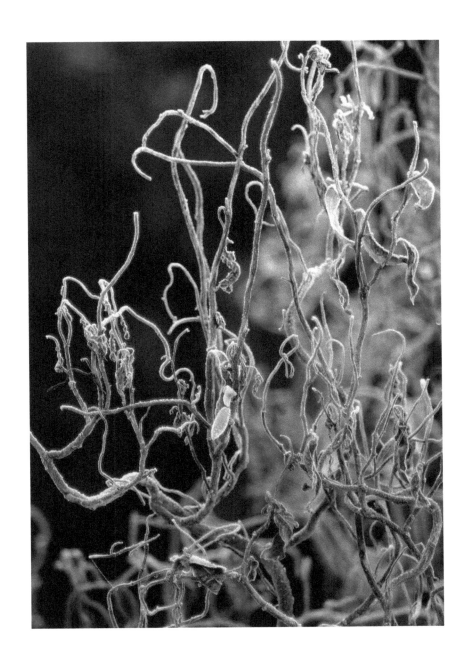

A Dusting of Snow

Our first winter on Exmoor arrived with icy cold winds, which cut through us, and heavy frosts but very little snow. Being unused to living up this high on the moor, we both felt like we were existing in a totally different weather system; it was a shock, that's for sure.

Looking back, it was a period of 'firsts' for us: first proper winter weather on the moor, first time that we'd been fortunate enough to have a woodburner to light, and the first time that we've had to deal with logs.

The woodburner kept the chill at bay inside the cottage and was a learning curve for my husband. For me, it was a return to my childhood and it seemed that I'd absorbed everything I'd seen my parents do, as they tended to the open fire in my childhood home. I'd unconsciously logged that information for this particular time in my life.

The woodburner was a life saver, not just for warming us, but for cooking meals on during the many, many power cuts we experienced those first few months. I would light the fire and place a casserole on to cook for

several hours, and the smell would reach every corner of the cottage. There is nothing like it on a cold winter's day and even now, many years later, I'd be hard pressed to find fault with it. The hearty casseroles just keep on coming.

It was the first time that my husband had to split logs to feed a fire. An order of logs had been delivered but we found they were a selection of shapes and sizes - too large for our woodburner. So, it was suggested that a large piece of tree trunk was sourced in order to split the logs on, and a piece was found down in one of the surrounding fields where it met the woodland. On a neighbour's tractor it was delivered, and the axe swinging began.

While my husband tackled the large beech logs, I was back in the shed, perched on yet another smaller piece of trunk, chopping kindling. I love wood. I love the feel of it, the smell of it and handling it. My dad was the same and I really think it stems from him. As a child I would accompany him in our pale-blue Dormobile van, to go and order a delivery of logs from the wood yard on a Sunday morning. When it arrived and was unloaded into the quiet road outside our house, I would help to barrow it through to the back garden, where we would stack it under the dining room window and cover the pile with a green tarpaulin. There was never the luxury of a log store for my dad: there wasn't the room.

Now, when we have our own delivery, I am in my element as they are tipped, unceremoniously, close by the

log store. As I move them, stacking and feeling the pieces of tree in my hands, I am back with my dad, all those years ago. I just love it!

One thing we don't have to contend with any more is the size of the logs as these days we aren't so green and our logs are cut to a manageable size before delivery. We still split some of them, as I think my axe-wielding husband quite enjoys the exercise, but it's not out of necessity. However, it does seem that when you're finding the weather finger-tingling cold, that nature and needs have a way of warming you up.

Within a few days of our first log delivery we felt the bite of the winter outdoors, but we had plenty of ways to keep warm both inside and out. We were gradually becoming accustomed to the weather and were hardening up with our axe swinging and log stacking. Once we had the logs, we had to have somewhere to store them, and plans, in the loosest sense of the word, were drawn up.

A wonderful, mini, three-sided type of shed evolved out of the ground, all from my husband's clever hands. It was his pride and joy and was large enough to store not only our logs but our starters and lighters too. The only problem was it was a wheelbarrow ride from the cottage, up a slope. So, my husband set about building a smaller version, closer to the boot room, which I could stock up for use during the day; it worked out well and is still there today.

Over the passing weeks we found that the larger store

doubled up as a perfect place to star-gaze from. We will often sit out there, with a glass of whisky in our hands, gazing up at the dark sky over the moor. Those of you that sit out at night, as we do, will know that the inky-black sky changes constantly the more you stare at it. The log store is an ideal place to look to the heavens and to see what's about, in comfort.

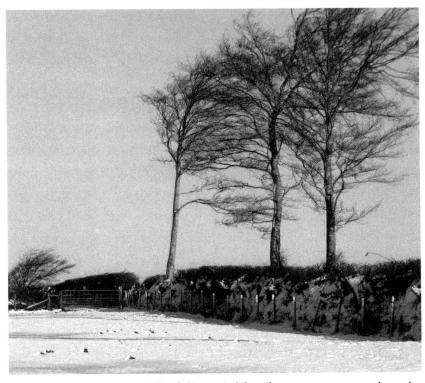

Our first snowfall fell quickly, late one morning in January. With the flakes fluttering down from a leaden grey sky, I was outside with my camera ready to record the whitening lanes, fields, and trees. However, the snowfall turned out to be more akin to a heavy snow

flurry but with flakes the size of a tea plate; it was sparse in places and short lived but left a dusting of snow across the landscape.

Against a suddenly alien blue sky, the fields looked fresh, clean, and sharp. Hedgerows stood out against the flowing patchwork of fields and the trees appeared to stand to attention, their branches silhouetted against the snow covering and sky. Quickly making my way around the back of the cottage, along the snow-edged lane and over two small fields, I left faint tracks behind me as I walked.

Reaching a place that overlooked the Barle valley, I rested my elbows on the old, characterful gate, scanning the scene in front of me. A small herd of red deer still grazed one of the fields as if the winter flurry had never happened. To say the view was stunningly beautiful, even with the lightest of snowfalls, would be an understatement. It was dazzling. I'd never seen snow on the moors before, hence my excitement and hurry to be outdoors and, as delicate as this current dusting was, it truly entranced me.

I've lived in a rural setting for some years now and witnessed heavy snowfall along with many others, but on the moor it seemed altogether different. As I stood there in the particular stillness and peace that only snow can give us, I came to wonder what difference a heavy snowstorm would make to the terrain. Even a shallow covering was making a world of difference to what I saw

before me, with the fields laid out like a jigsaw puzzle, and the deer no longer able to blend in with the colours of the moor.

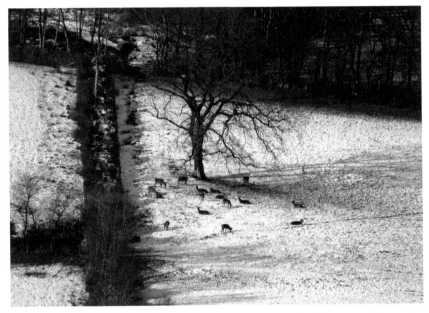

The light dusting of snow was enough for me, though, and as I made my way back across the fields it was already beginning to melt. It had lasted all of an hour or so but, with blue skies such as those above me, it was no wonder it was thawing fast.

In the wide-open spaces of the moorland in the distance, the snow had already disappeared, leaving the brown bracken and heather exposed once again. The fields, lined with their dense beech hedgerows, were holding on just that little bit longer to the wintry weather.

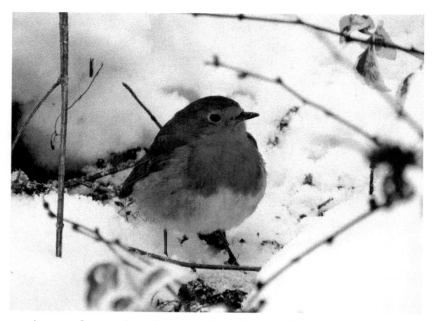

Apart from the deer, and a lone robin, perched on a small twig on the cold ground, not a creature stirred in the white landscape. The cheeky robin was enough to make me smile, though, its buoyant nature at one with the happy, seasonal feeling of Christmas, which had not long passed.

Snowdrops, ever present at this time of year, were beginning to poke their delicate but hardy heads out of the iron-hard earth. Up early and facing the inclement weather, they looked at home with their white cloak of snow brightening up the surrounding soil.

It seemed surreal that I stood under clear blue skies, in bright sunshine, with snow around my booted feet. Just the coldness nipping at my fingertips, where my hands had held the camera, assured me that this was, indeed, January.

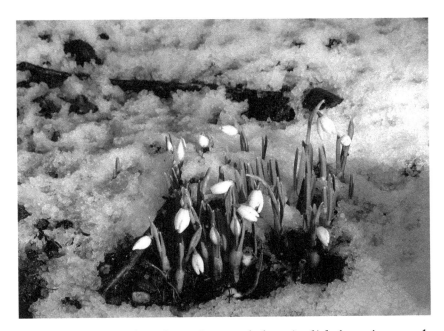

Winter had tried to bare its teeth but it didn't quite work out that way. I returned to the garden the long way round, via the fields, climbing a metal gate and dropping down on the other side. One more triangular-shaped field, another gate and I'd reached home. I found myself gazing across the lawn in the top garden towards the bird table, which I'd yet to replenish this morning; it was a chore that needed doing.

The narrow lane beyond the gate was becoming slushy, the snow disappearing as quickly as it came to us, and I wanted to head indoors to the warmth of the cottage. Yet it appeared as if the snow was magnetic; it pulled me towards the front gate for one last look across the fields and along the lane. Exmoor called to me and, as is always the case, I went.

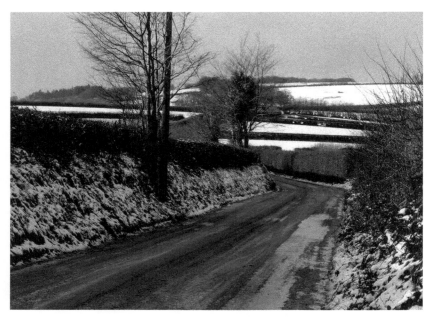

From my viewpoint I could see that the snow was melting fast. There were small pockets of grass appearing all across the fields, giving a dotty, dappled look from afar, and my own footprints, made earlier, were fading. There was a small herd of red deer, two fields over, grazing where they could, beneath a tree. Finding it weird, but wonderful, that they could be so easily spotted against the now patchy snow, I hoped that they'd be safe.

Twigs and stems poked through the last of the snow clinging to the banks and the lane was coming back to its usual seasonal colour. As the wintry covering slid away onto the lane, so puddles formed – I crossed my fingers that the temperature didn't drop enough for them to become icy patches overnight.

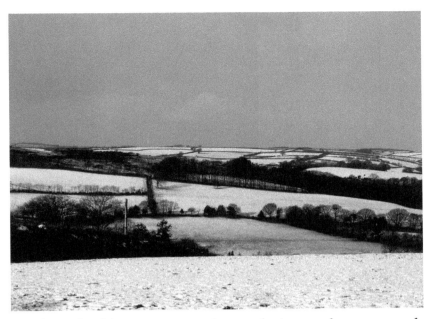

There had been too much pondering and not enough doing – a trait of mine – but I eventually turned my attention to the bird table and a poor fluffed-up robin I'd seen earlier. He would have given up on me by now, I thought. I really should have re-stocked their restaurant first, just as my mum taught me to do, before wandering down the lane to satisfy my curiosity.

It was a trip down the narrow pathway, running between hedgerow and field, to the shed for bird seed, mealworms and suet pellets: life-saving food for my hungry visitors. Only then would I be able to venture inside to the smell of a pork-and-apple casserole simmering slowly on top of the woodburner. It wouldn't be ready yet but the wait would be worth it, no doubt.

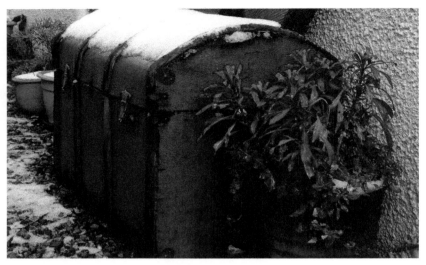

As I reached the back door, my old, worn travel chest sat there, its white topping of snow reminiscent of the frosty icing on a delicious cake. The large chest had been with me for years, withstanding any weather that was thrown at it. It belonged to Gordon, an elderly neighbour of ours who, having plans to move to a smaller property, asked if I would like it to look after. I do know that it was used as one of two family travelling chests, utilised by his parents when they holidayed out in Wales. Gordon had great pleasure in telling me that the chests would be packed with clothes and linen and sent on ahead in readiness for the family's arrival. Each and every year it has a refurbish, a re-wax and protection for the coming months.

It sits quite well against the wall of the cottage, along with my 'cuckoo stick', a tangible memory of my first sighting of the elusive cuckoo, up on the moor, many years

ago. I'd picked it up as we'd made our way up from the steep combe, where we'd sat for hours watching and waiting that day. It now served as a constant reminder of how lucky we were to be able to revisit that particular spot each year, and to hear the cuckoo calling. Both my beautiful chest and my crooked cuckoo stick still sit outside the back door welcoming all those that visit the cottage.

Before stepping inside, out of the chill, I glanced up at the chimney pots above the tiled roof, as I did on a regular basis, and could see that the snow was in definite contrast with the blue sky. It didn't seemed real that, just over an hour before, snowflakes had flurried from the steely sky overhead. The grey had turned tail and run, and had left us with the glorious blue of a summer's day, the sun a weak reminder of what was to come in the months ahead.

Pushing the door open, I stepped over the threshold of our boot room, dropped the logs, which I'd carried from the log store, into the basket, and kicked off my boots, leaving my warm, thermal socks intact for the time being. It had been an energising couple of hours or so outdoors, and I'd thought about all those hours of log splitting, carrying and stacking while I'd wandered about in the snow. All the trips for starters and lighters over the fields and along the lanes, during the windy, gusty months were worth it when there was a fire at the heart of your home.

It was by that fire that I eventually sat with a warming coffee and a piece of beetroot cake, contemplating my lunch. All I seem to think about is food on these cold and wintry days but I suppose there are worse things to occupy your mind.

The Beast from the East – a Recollection

The Beast from the East was coming to the south-west and we were in Kent, staying with family. Knowing we had to travel home as soon as possible, we left a day earlier than planned. My daughter packed us up a huge food hamper (which would have fed a group of six on an ascent of Kilimanjaro, such was its content!) and, together with the feast, we had pillows, feather-filled sleeping bags and flasks of tea and coffee. Fully equipped for whatever the weather could throw at us, we already had our boots, snow socks for the 4x4, a shovel, and some pieces of carpet stowed in the back. Call me old-fashioned, but my motto always has been 'be prepared!'

To travel the 230 miles home, according to the travel websites, was going to be epic, but we knew we had to make it home before nightfall. Choosing not to touch the A303, we took the M4 route, making our way to Bristol. If the weather was coming in hard then the plan was to hole up in Bristol until we could travel on.

Travelling the M4 we watched red kites circling above us as the snow flurries began. Their tell-tale form stood out against the heavy snow-laden sky, the steel-grey of the clouds ominously hanging above us, waiting to burst. Ensconced in the warmth of the car, we could see it was a very different world outside.

Usually a four-hour journey, we'd already been travelling for six once we'd reached the M5. With the going good, despite the snow flurries, the motorway journey passed by, albeit taking longer than usual. We were yet to hit Taunton when we stopped for a comfort break and a purchased coffee. Then we pushed on – and lucky we did!

As we passed over junction 25 it was as if we'd arrived in another world. We went from snow flurries to a constant, heavy barrage of large, fluffy flakes, with three lanes quickly becoming two lanes and then one. The snow was blowing across the road, swirling in every direction, and covering the hard shoulder and the road markings. The only visible lane was the outside one and we used the barrier as our guide, following in the tracks of a line of slow-moving and sensible traffic.

We heard on the radio that the A303 had been closed with cars stranded along its length. Although we'd taken the longer route, we were thankful we'd made the right call. Reaching the A361 eventually, we continued on one lane with very few vehicles about.

It was around four o'clock as we turned off onto the road home. Exmoor was calling and home would normally be a mere thirty minutes away but we knew this would be an uphill struggle, literally.

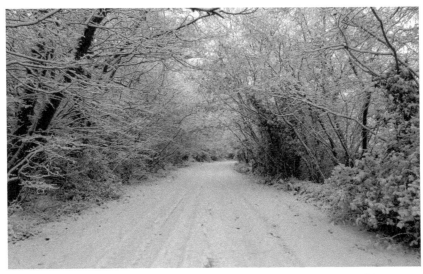

Stopping in a lay-by to pour yet another coffee, we assessed the situation and chose the route that would serve us best. The trees, heavy with the snowfall, framed the road beautifully in the last light of the day, the patterns they were making artistic in their simplicity.

With the wipers swishing fifteen to the dozen, we slowly climbed the hill towards South Molton, turning into another lay-by as we reached a plateau on the road. It was here that the decision was made to don the car's snow socks. We'd been lucky so far, but with some uphill bends to contend with and the snow now falling with a

vengeance, we feared we'd need their assistance along the narrowing lanes.

I patted the bonnet asking the car to 'do her stuff and get us safely home', before getting back into the warmth, looking something akin to a snowman. Snow was beginning to drift against the gateways, which were open to the elements. Slowly, we climbed the hills and took the bends; there wasn't another soul around.

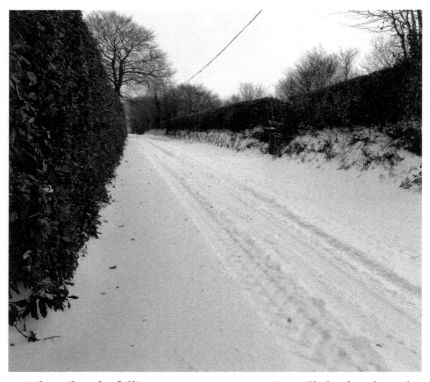

The silently falling snow was covering all the landmarks that would guide us home, the edges of the lanes disappearing under a mantle of white. All was peaceful and quiet … apart from us, motoring slowly along, the

snow socks thankfully doing their thing when they were most needed.

Surprisingly, they were making easy work of our progress thus far. Leaving our tracks in the newly fallen snow, we came to level ground again, our tyre marks quickly disappearing as more snow fell. We were on the home straight and we knew that around the corner was home. We'd been travelling for eight hours, and it felt like it.

Already dressed for the elements, I jumped out to open the welcoming gate and had to put all my weight behind it to push against the gathering snow. One reverse and we were in, home and safe.

Phone calls to family could now take place to stop them worrying and we'd do that as soon as we were indoors. We'd been in constant touch, en route, with our wonderful neighbours, and we'd called to let them know of our imminent arrival. If we'd have got into bother, they would have come out to rescue us for sure, having the vehicles to do so.

We found two fluffy jacket potatoes with lashings of baked beans waiting in a warm oven for us, ready to be consumed. In the fridge sat a container of extra mature grated cheese together with fresh milk and a loaf. The woodburner had also been lit, its gentle flames warming our hearts as well as our bodies, and the heating was on, warming the rest of the cottage.

It seemed like the fairies had been in and readied our home; our neighbours are priceless, bless them. We do try

to look out for each other, here on the moor. It wasn't unusual to find steaming hot jacket potatoes hanging on the back door, safely wrapped in foil, in an insulated bag, if we'd been out for the morning on errands, just as we would prepare a meal for our neighbours if they'd been out and about for the day. To come home to a cooked meal, and friends waiting to hear about your day, was always a welcome bonus.

Not knowing what tomorrow was going to bring, we had a quick unload of the car, put the kettle on to boil and sat down to some hot food and a steaming cup of tea. It was good to be home. With one last look outside it was obvious that the wind was picking up and, as the last of the twilight faded away into the night hours, we could feel the temperature begin to drop even further. Looking up, as the snowflakes drifted and swirled around us, we knew that, come tomorrow, it would be much, much worse. Giving up silent thanks for our safe journey home, we took ourselves off to our much-needed bed and sleep.

Waking to a silent world in the early morning, it felt eerily quiet. Outside there wasn't a sound, and there was an abnormal brightness to the room. When we drew back the curtains, we realised why that was. Winter, it seemed, was baring its teeth and had come to Exmoor.

In places the snow was around a foot deep even on level ground, the drifts against the gates three times that height. Our steps up to the top garden had completely disappeared and the bird table was like a snow block.

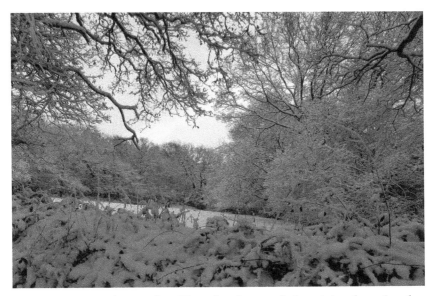

The Beast from the East had certainly visited us in the night hours, and it was still snowing! Getting to the outside was going to be fun as snow had banked up against the doors, the door steps disappearing. It was worse at the back than at the front so we opted to clear the front door first and make our escape, once the cottage was in order. After a hot breakfast, our morning cuppa, and with chores completed, we togged ourselves up to begin cutting a pathway to our well-stocked log store and the gate, which was also snowed in.

Not that we were going anywhere in a hurry but it needed to be done before we took ourselves over the fields for a leg-weakening wander. Working together, we watched our breath frosting in the cold air. Everywhere was so settled, so fresh, but needs must and we continued to shovel and clear the mounds of snow.

As we cleared, a buzzard chose to land on one of the fence posts that run up the side of the paddock. He sat against the cold, snowy background for some time and long enough for me to grab my camera. Posing done, he launched himself off skyward towards the fields: a most welcome interruption to the clear-up operation.

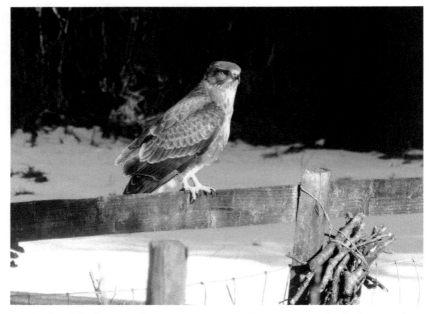

I decided to cheat on our dinner, and defrosted a shepherd's pie that I'd made and tucked into the freezer a few weeks before. We would have it with vegetables from the garden, I thought, followed by a homemade rhubarb crumble.

The day was now our own to enjoy so, checking in with our neighbours first, we backtracked past our cottage and trudged across three fields towards our view over the

Barle valley. It was so unstirred: a blank canvas, ready and waiting for Exmoor's folk and creatures to lay down the first signs of life onto the pristine landscape.

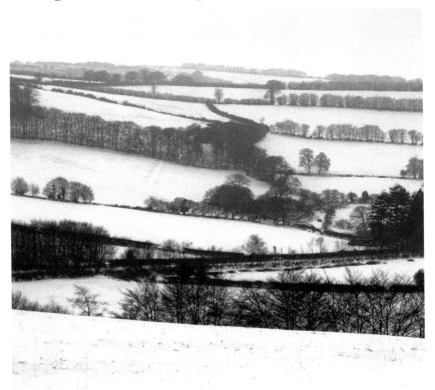

Before us the vista was breathtaking – a stunning panorama white-iced by nature – and I don't think I'll ever forget seeing the spotless purity of the fields, the majestic splendour of the snow-covered trees or the contours of the land, deftly picked out by the 'Beast'.

As we stood there, we noticed that there were very few birds about. The only animal tracks we'd seen were those of a fox along the edge of a field. The small paw holes

were evenly spaced and eventually disappeared into the hedgerow. A shout went up from behind us and there stood our neighbour, wielding a red, plastic sledge above his head as it caught in the breeze. Leaving his tractor at the edge of the field, he met us half way and wished us fun in the snow with our new mode of transport. What followed was an hour of pure hilarity as we sledged down the sloping field towards the snow-covered woodland.

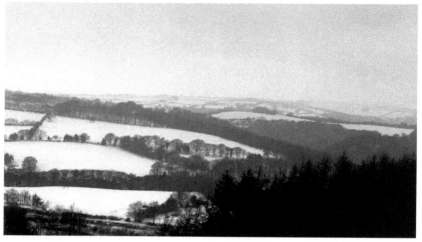

As we gathered speed, the fence coming towards us at a rate of knots, we squealed at the (thankfully unfounded) fear of careering through the wire fence and down towards the badgers' sett.

To climb the hill, over and over again, was exhausting in the deep snow. It was flattened in places, with sledge runs and our boot prints, but large, fluffy flakes of snow were beginning to fall again from a very snow-laden sky.

Soon our desecration of the virgin snow would be gone, our tracks covered without a trace.

Deciding we'd had enough, we began our walk back home and, reaching the top of the field out of breath, we heard a tractor approaching. Our lovely neighbour was coming to our rescue! We attached our little red sledge, via a long rope, to the rear of the tractor and, feeling chilled and somewhat damp, we were towed home, being hauled over the snow, across the fields, and enjoying every single minute of it.

As we tucked into our shepherd's pie and veg in the warmth of the kitchen, we relished the thought of being sat before the woodburner with a glass of something warming later that evening. It's at times like this that we give thanks for a roof over our heads and food in our tummies.

So many people wouldn't find themselves as fortunate. All we'd have to contend with the next day would be some aching muscles and more snow clearance. We would never take for granted how lucky we were. Before retiring to bed that evening, closing the curtains and doors on the world of white outside, we peered across the light, bright landscape to the front of the cottage.

The white fields were punctuated with small dots of glowing orange-yellow lights from distant farms and houses. Dense lines of snow-covered trees picked out the patchwork of the pastures as they cut their way across the land. Tomorrow was another day, the snow-ploughing tractors would be out and about and in a couple of days, given there was no more snow, we'd be on the way to normal again.

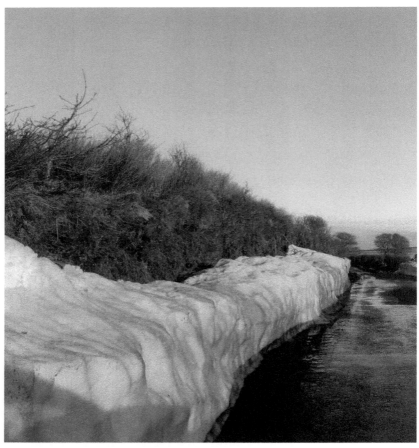

The Beast from the East had given us a wheelbarrow load of emotions: urgency, fear, hope, relief, togetherness, unity, and happiness. But most of all it strengthened our knowledge that good neighbours are something to be treasured. We'll never forget their kindness in readying the cottage for us and leaving us a hot meal. We are blessed and they are priceless!

A Wander Down a Welcome Track

We were woken this morning by the tap-tap-tapping of the blue tits on the bedroom window sill.

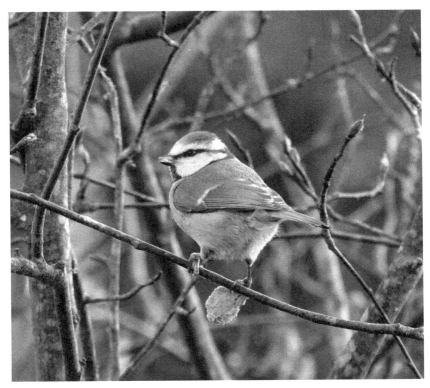

Coupled with the stronger pecking of that coming from the guttering, and which belonged to our cheeky jackdaw friends, there didn't seem to be a clearer message that the bird feeders needed replenishing. To complete our own personal wake-up orchestra there were pheasants cackling down in the garden, busy in their quest to ruin my flower beds.

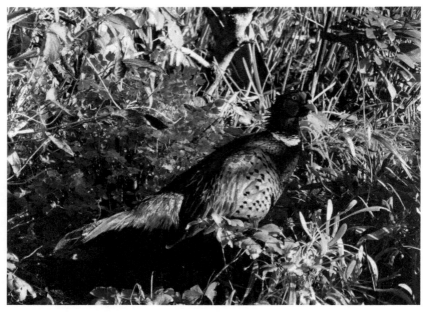

Another day on Exmoor had begun. Having not had any rain for a few days, we've been able to work in the garden dismantling our old shed and we were positively astounded by the view its removal gave us across the garden and fields. It shouldn't have come as any surprise, but it did, and all the weeks of battling against the weather (Storm Eunice included) with the construction of our new shed and log stores seemed worth it now.

It had been a slog, with a love-hate relationship, but there was definitely more love about, now the job was done! And a welcome bonus was that it was another dry, clear day. Extricating myself from a very warm and comfortable bed, I traipsed downstairs to make the morning cuppa and to coax the woodburner into life.

It's a rare thing that I don't throw back the bedroom curtains before coming down the stairs, but I didn't want to disturb the blue tits at the windows, giving them false hope that their 'chef' was up and ready to tackle the chill outside. Well, not until I'd had my morning sustenance.

I was observing the busy birds yesterday as we worked in the garden and noticed that they were so very vibrant

in their plumage. The blue tits positively glowed in their blue-and-yellow finery; the blue cap on their little heads standing out like a beacon: a calling card to all the females if ever I saw one.

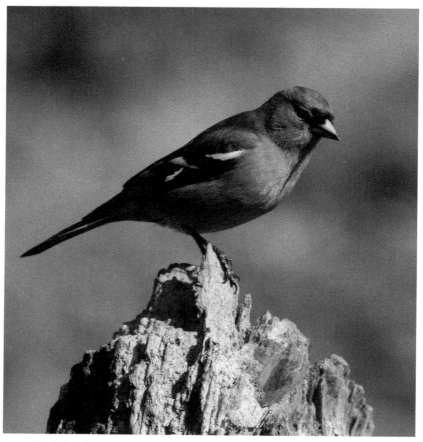

Chaffinches were sporting their beautiful dusky-pink breasts. The long-tailed tits looked as if they'd been painted by a master of the arts with their creamy-pink and black-brown stripy colouring, and the robins were positively vibrant.

One brave robin in particular felt quite safe to potter about around us as we worked together lifting the old and rotting shed base. All day he was there, ducking in and out and picking up all manner of delicious creepy crawlies. I do love it when the robins keep me company in the garden. I had some dried meal worms in my large gilet pocket, and tempted him closer and closer as the day wore on. As a fan of the new *Worzel Gummidge* series, I named him Winter George after the resident robin on the programme. Our grandson will love the name!

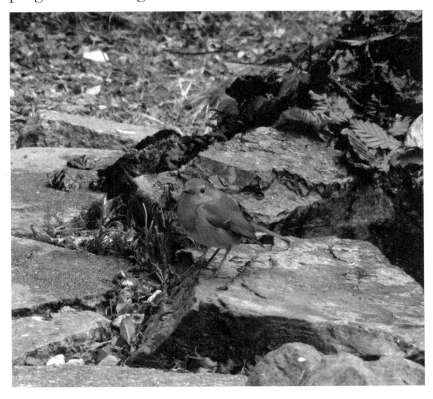

The birds, together with the emergence of the purple and white crocuses, and golden daffodils, brought a long-awaited springtime vibe into our lives and it felt good.

~

My thoughts now, though, pass to a day, many years ago, when our good friend, Johnny Kingdom, pointed us in the direction of what can only be called an ancient dirt track. It's banked on either side by ancient hedgerows and narrowly winds its way down into a valley. It's a there-and-back walk but an inspiring wander to say the least. Johnny, with a twinkle in his eye, told us to pay particular attention to the fourth field down, on the left-hand side. That particular treasure will forever be a secret now, but we've walked the track more times than I care to remember, and we've never been disappointed.

Today we're going to follow it again, so it's down the curvy staircase, a breakfast of eggy bread and out the door for us. I think we deserve a wander after all the shed building and weather-wrangling of the past weeks. We find the lane outside the cottage quiet, the beech hedgerows sporting crispy, crunchy leaves of brown, the skeletal trees allowing the light through their tall branches. It's not sunny but it's still quite light and it's extremely welcome.

Across the moorland we travel at a suitable pace to take in all that's around us. High in the sky we spot three buzzards, which quickly become four, their tell-tale mewing amazingly reaching our ears down on the ground.

They circle around each other, wings outstretched, and we can clearly see their pale markings as they descend slowly towards us. Without warning, wings are folded in and they dive towards the ground in a fantastic display, solid black silhouettes against the sky. As quickly as they changed shape for the plummet to terra firma, they're up again and soaring, climbing high once more, circling and mewing. They're a sight never to be missed – we stop to watch them for a while before pushing on once again.

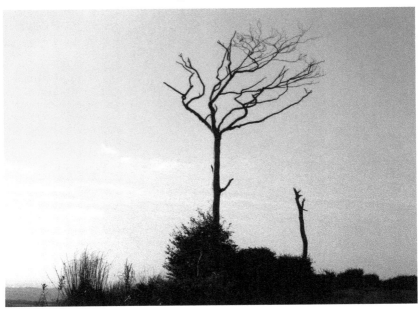

Along the lane and over, we reach our destination, and we stand and take in far-reaching views across dense pine woodland, a patchwork of fields and multi-coloured moorland. We know the walk will take us downhill and our view will quickly disappear as we are swallowed up by the beech and holly hedgerows and nature itself.

At intervals we'll come across gates and, therefore, gateways and I can indulge myself with my favourite pastime of 'gate stroking and patting'. We've walked this way so many times before and I've probably contributed to the dips and wear to many an old wooden gate along this pathway, adding my touch to those that have gone before me, and I'm sure there are tales to be told by this track and its surrounds.

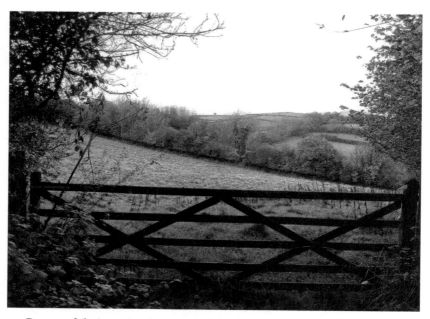

It wouldn't surprise me if fellow walkers passed by the opening to the track, deciding it not being worth a look-see. Some places are like that and, believing them to be a nonentity, people walk on by and fail to investigate what they have to offer. I have to admit that if we hadn't been directed this way, then we'd probably fall into that category, too, regarding this self-same dirt track.

What delights we would have missed had that been the case. To look at it, it's not special but follow the grass-covered ruts and a whole new world opens out, unfolding its layers. Following the soft bends there's always something new to discover, whatever the season. Each bend teases our sense of curiosity and adventure, even though we've seen it all before. But that's Exmoor for you, each day is a new day with an ever-changing view.

We have never passed another human being while walking this way but we hear sounds aplenty. Tractors and quad bikes work away in the distance, hidden from view as we descend the track. The sweet song of a cheeky robin, a little brown dunnock, and the distinct call of a secretive wren all keep us company as we wander. In the confines of the close hedgerows their song is amplified, a welcome soundtrack to the quiet of the day.

Even though we hear the various sounds of the countryside, it is peace personified and we're happy to amble along together. On either side, beyond the borders of the hedge, lie pocket-sized pastures, tiny in comparison to most agricultural land. Many are homes to small flocks of sheep but most remain empty, growing in a natural state and surrounded on each side by further hedgerows and trees, encouraging wildlife to not only live but thrive.

On a gently upward-sloping field we spot a bird of prey on the ground, wings outstretched and covering something, its back to us. We determine that it's yet

another buzzard, small in stature but putting all its energy into feasting on its quite substantial lunch.

Leaning on an old but sturdy gate, we take a break, crack open a finger of fudge to nibble on, and watch. After around ten minutes, the bird turns in a circle, holding its prey in its talons and we can see tufts of white-grey fur dotted about nearby, in stark contrast to the emerald-green of the grass. Flying to perch on the lower branches of a nearby beech tree, the buzzard looks our way, fluffs its plumage up with a good shake and appears to be staying put. Snack finished, it seems – for both us and the buzzard – we move on and continue walking downwards.

Under the hedgerows, in this very sheltered spot, some snowdrops still remain. Being well past their best now, many sit in the green, re-energising themselves for next year's performance. They bring back memories of my mum singing these words to me as a child when we spotted the first snowdrop along the way. They're from a poem by Annie Matheson I believe and, to this day, I still sing them, not just to the wind but to my grandson too.

'Where are the snowdrops?' said the sun

'Dead' said the frost, 'buried and lost, every one.'

'A foolish answer' said the sun

'They did not die, asleep they lie, every one.

And I will wake them, I, the sun,

Into the light, all clad in white, every one.'

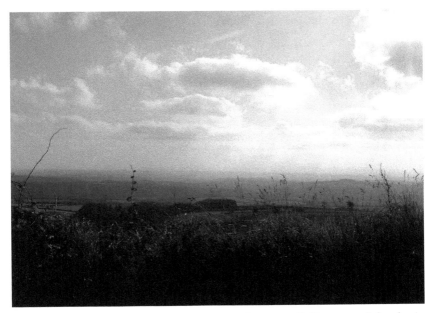

Back at the cottage my snowdrops, delicate with their citrus centres and lace-like petals, are well and truly in the green and it's time to split them and share them about the banks of the garden. They've been prevalent along the lanes of the moor, and it has gladdened my heart to witness their hardiness against the winter weather. Even Storm Eunice couldn't upset them, such is their bravery.

There are snowdrops aplenty dotted around the garden in fair-sized cushiony clumps, and each year they expand a little further. I would, however, never bring snowdrops into the house as I deem them very unlucky when they're inside the four walls. But outside, for me, they herald the turning of the winter and the coming of spring as they pass over until next year.

The snowdrops under the hedgerows here will soon lose what remains of their tiny white gowns and will join their bedfellows in the green, asleep for almost another year. But their place will be taken by the yellow lesser celandine and clumps of lemony primroses, both an absolute joy at greeting the spring.

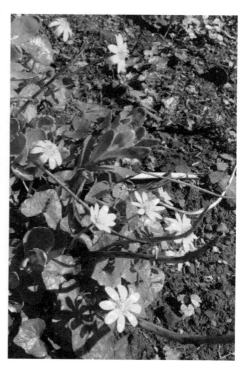

The bright yellow flowers and glossy leaves of the lesser celandine will shine out from the shadiest bank or hedgerow. We have them emerging from the gravel drive at the cottage and find ourselves sidestepping our way around them on a daily basis. I've tried to move them to a more suitable place but they're having none of my shenanigans and insist on coming up year after year, despite my efforts. They obviously enjoy the driveway so who am I to try and give them a better home.

Always on the lookout for the elusive hare – black-tipped ears, standing tall, and fleet of foot – our binoculars are at the ready should the nudge come from either one of us. It's good hare terrain and, should we

have come earlier on this morning, I'm sure we would have been lucky enough to spot one or two. The day is tramping on, however, and emerging out the end of the dirt track we peer up and down the narrow lane junction. Turning on our heel, we decide that in another hundred yards we will take a pew and treat ourselves to a coffee. It will spur us on for the slow and steady incline back up the peaceful track.

It's a nondescript track from the top, which doesn't open out as you walk, but rather closes in around the wanderer as it narrows. As part of Exmoor wraps itself around you, the track cossets and cuddles you and gives you everything it has to offer … all the way there and all the way back again.

Once at the top, where the track opens out somewhat, we halt our feet once again and look towards the expansive scene before us. The uneven line of the horizon is marred now by low cloud, the temperature, now we're out in the open, somewhat cooler despite the warmth from the walk. It is time to head for home, where I'll probably split my snowdrops while my husband splits some logs. After all, we have a new and rather large log store to sit them all in now. As I said, we've been all the way there and all the way back again; a simple wander down a simple path but, after the trials and tribulations of 'Shedgate', a wander down a welcome track was all that was required.

About the Author

Ellie is the wrong side of sixty (her own words). She is married with two grown-up children, loves to be outdoors, and now lives on Exmoor with her husband. Originally moving to Somerset in 2004, she began writing thoughts about her life on the moor around 2013, a year before her youngest grandson was born. She felt that she needed to start a diary of sorts: in this way all three of her grandchildren would be able to learn what her life was like on Exmoor. Not having that kind of information about her own parents or grandparents, it spurred her on to making a record for them, so that they, too, would fall in love with the place where she lived. Writing from her Exmoor cottage, a cup of lemon-and-ginger tea to hand, together with a slice of homemade cake, Ellie knows that she has come home.

Acknowledgements

My husband accompanies me when we are out and about or simply working in the garden. He's less available when I'm cooking, although he does appear when it's tasting time. It is mostly thanks to him that we have some wonderful photos to bring my words to life; he is a diamond and also the glue that holds me together when my confidence fails me.

I must thank the custodians of the cottage whence I've penned my stories. They know who they are. The cottage is the heartbeat of my words and without its presence, and their understanding, I may not have started writing at all.

I cannot go forward without mentioning the inimitable Johnny Kingdom. He was an inspiration to my husband and me as well as a good friend. The kindness he showed, and knowledge he imparted, is everlasting.

My final thanks go to Olli at Blue Poppy Publishing. Thank you for seeing something in my words that others couldn't or wouldn't. You have made me smile, jump up and down, and cry, all at the same time, and I cannot thank you enough for giving me the chance to have a book published for my three amazing grandchildren; your help has been priceless. Sink or swim, it will be a legacy left for them, for always.

About Blue Poppy Publishing

Blue Poppy Publishing is a small independent publisher with big ambitions. It started in Ilfracombe in 2016 when Oliver Tooley wanted to give his self-published novel an air of credibility. The name was inspired by Oliver's grandfather, Frank Kingdon-Ward, who famously collected the first viable seed of *Meconopsis betonicifolia*, the Himalayan blue poppy. Blue Poppy Publishing now has dozens of titles by twenty or more authors but still has a way to go to compete with the big guns.

As a small business we depend on word-of-mouth far more than others so please, if you have enjoyed this book tell others, write a review, blog about it, post on social media.

This book is the second to be published in a four-part series, with one title for each season.